Richard Smith
Recent Work 1972–1977
Paintings, Drawings, Graphics

Richard Smith
Recent Work 1972-1977
Paintings, Drawings, Graphics

Hayden Gallery
Massachusetts Institute
of Technology
Cambridge, Massachusetts
March 17-April 19, 1978

Organized and sponsored by the
MIT Committee on the Visual Arts

Supported in part by grants from
The British Council and the
Prudential Insurance Company
of America

Distributed by the MIT Press
Cambridge, Massachusetts, and
London, England

Travel Schedule
Chrysler Museum, Norfolk, Virginia
Walker Art Center, Minneapolis,
Minnesota

Design: MIT Design Services
Printing: Rapid Service Press
Text Type: Helios
Typesetting: Eastern Composition
Paper: 80#LOE dull coated text, 65#
Strathmore Pastelle Cover

Library of Congress catalog card
number: 78-53067
ISBN: 0-262-69061-6

Although British artist Richard Smith
has a distinguished international repu-
tation, his "kite" paintings, which have
been produced over the past six years,
have not been seen retrospectively
before in America. Rather, he has been
known here in recent years primarily
for his masterful graphics. Yet, several
key works of this period are in fore-
most American collections, both pub-
lic and private. These form the nucleus
of the MIT exhibition while a group of
works from England complete the
survey.

The impetus for this show at Hayden
Gallery grew out of a longstanding
admiration for Smith that began when
he was involved in the mid-60s with
a series of sensuously molded, delect-
ably colored canvases, one of which
is a highlight of the MIT Permanent
Collection.

Smith continued until around 1972 to
pursue the ramifications of literally en-
gaging the shaped painted surface
with its spatial surroundings, but the
genesis of the sheet-like, lightweight
canvases which constitute the present
exhibition may be traced to *Gazebo* of
1966. This free-standing tent environ-
ment of irregularly contoured canvas
sections was commissioned for the
Architectural League of New York. The
concept of looking into, up at, and
around, the revealing of inside and
outside, the spirit of levity, all had
important implications for the kite-
works. Also formative was a tent
project Smith conceived that year for
the Aspen Design Conference.

Finally, though, it was Smith's ten-year
dialectic between volume and two-
dimensional surface that established
the basis for the present body of work
— cutaneous surfaces, hung individ-
ually or overlapped serially on the wall,
or strung out and suspended from
above. In these pieces, visible support

mechanisms, such as aluminum rods or tubes, become a crucial part of the paintings' imagery. Threads, string, ropes or tapes which articulate the thinly painted canvas ground also act as equivalents for brushstrokes and line drawing, and often are accompanied by painted bands or squares.

Smith's sensory input straddled the Atlantic even before he made his mark in the early 60s as an innovative exponent of Pop-tinged modernism. Although his first pictures were inspired by Francis and then Rothko, Smith took his iconographic cue from insights into the perceptual influence of mass media and popular culture already manifest in London in the early 50s. During his stay in New York intermittently from 1959–1966, Smith developed a personal response to the commodity world that surrounded him. Unlike the overt figurations of Americans Oldenburg, Dine, Indiana and others involved with similar pursuits, Smith's work throughout the 60s, even at its most flamboyant, subsumed its tangential thematic source — whether common object, commercial product or an encounter with everyday existence — to a fundamental concern with issues of scale, surface and color. As has been pointed out before, it was tempting to attribute Smith's markedly restrained "pop" manner to the prototypical English temperament.

The new works possess an impeccable refinement that builds on this attitude of reserve. All have literal derivations but the allusions are even less accessible. Now it is the materials more than the images that serve to invoke the commonplace. These "dime-store" elements (string, tape, rope, etc.) are the vocabulary of packaging. Their use connects Smith to certain American artists in the late 60s like Hesse, Le Va, Serra and Sonnier, who employed "non-art" materials to establish

a discourse with process and facture and the democratization of art experience.

Smith, too, has engaged in an honest explication of the phenomenon of process. The physical structure and hanging methods are simply presented, in contrast to the complicated, hidden skeletons of his earlier constructions. More than such artists as Ryman, Tuttle, and Shields, to whom his work bears affinity, Smith produces objects that remain within a pictorial tradition. Whereas most of the process artists abandoned conventional supports, illusionism, and often the canvas itself, Smith continues to manipulate these elements but with refreshing conviction. The stretcher may no longer establish the shape or edge, but it still functions as support. Pictorial depth may be obliterated in each single surface, but the layering, though planar, still achieves spatial quality.

What may be, finally, the most compelling virtue of Smith's recent work is its synthesis of contradictory modes. By subverting the conventions he sets forth as representative of a particular disposition, tensile ambiguity results. The preoccupation with simple geometric shapes, the continued reemergence of a grid structure, the assertion of the vertical and respect for the single image suggest the classical tenets of 1960s American abstract art. At the same time Smith confirms his romantic roots: the need to render the surface "touched," to deal with levity as well as gravity, to express the notion of the hand-made, to endorse art-from-life sources, to sprinkle high seriousness with light-hearted whimsey and unabashed epicureanism.

I should like to acknowledge the assistance of all those who helped in the realization of his exhibition. I am

indebted especially to Richard Smith who was unfailingly supportive throughout. Irena Hochman, Director of Bernard Jacobson, Ltd. in New York, offered invaluable expertise, and Elizabeth Horton of the Committee on the Visual Arts staff compiled the catalogue material with diligence and efficiency. My thanks also to Bernard Jacobson, Donald Young, Diane Fuller, Connie Rogers, Joan and Roger Sonnabend, Sydney and Frances Lewis, Fred Brandt and Rita Salvestrini for their special efforts in paving the way.

Wayne Andersen has contributed new insights into Smith's work in his incisive essay. He first introduced Smith to MIT in 1967 and always has encouraged the idea of a Smith show at Hayden Gallery. The lasting significance of the project is to his credit.

Marjory Supovitz

Richard Smith:
Painting As Reality and Metaphor
By Wayne Andersen

After all, the foremost task of the painter is painting. If the painter doesn't paint, nothing will result. That sounds like a simple-minded tautology, but it's not at all simple for one who picks up the paint brush and by definition as artist is obliged to paint — with what? on what? what?

Painting was once a kind of negotiating process: a transaction carried on between artist and appearances, the record of it recorded in paint on canvas. The artist negotiated with the emerging imagery, conferred with it, arrived at a more or less final settlement, and moved on. The canvas one had to deal with, too, but its demands were few. It was rectangular and flat, virginal in the even-textured whiteness of its surface; its skeletal structure ubiquitous and hidden discreetly from view. The stretched canvas was passively accepting: it asked only that the artist respect its surface and edges and keep its naked backside to the wall.

A lot has been forgotten about the process of making paintings in the early and mid-50s now that Pollock, de Kooning, and Kline have assumed the quality of old masters and their myriad brush-wielding followers are less noticeable. One recalls Pollock wildly scattering skeins of paint, de Kooning in his studio with as much pigment on the floor and himself as on his canvas, Hofmann's studio drop cloths stretched as paintings, Goldberg's fall from his stepladder when he flung his house-painter's brush too violently in a gesture sure to produce drips and runs, Klein coating nude models with paint and pressing them onto canvases, Mathieu in soldier's battle gear assaulting a canvas to the accompaniment of a military band.

Though much of what painting underwent then became caricature in the hands of second-rate painters, the dead seriousness of it remains integral to modernist attitudes about what the painting process involves. During the 50s painting expanded upon modernist realism by incorporating the canvas and pigment into the painting's reality and in the early sixties especially, the reality of shape and support structure was added. Artists' preoccupation with media helped condition the shift of their attention in the 60s to mass media; the concern with production to the momentary acceptance of mass production; the emphasis on technique to an art of process; the reality of the canvas stimulated the shaped canvas; the problem of installation became installation-as-art. Aptly, the exhibitions in this country that ushered in the art of the 60s were titled, The Art of Assemblage, The Optical Eye, Happenings, and New Media–New Forms. Respectively, they acknowledged the way of making, the way of seeing, the action of the artist as art, form as media and vice versa. The residual fictiveness of art gave way to an outrightly realistic one — a fictiveness of reality, that is. Even the visual kinetics of optical art could be thought of as actual optical transactions rather than devices of illusionism. In all these examples the norms of the medium alone could suffice as the matter of art.

But not entirely. The kind of reality given painting in the 60s, here and in England, was as local and transitory as earlier realities, and as much dependent on sustained definitions of art experience. Painting, like sculpture, continued somehow to be "art." The nature of it was construed with increased strictness; process and product confirmed one another as always. One could still distinguish art from artiness, art process from just illustrations of process; and value judgments continued to uphold artistic consciousness. "Anti-art" was a catch word only for the faint-hearted who thought they

were destroying art when they assaulted its reigning hypotheses.

It is not my intention to detail these generalizations, which are supported by the best criticism of the last decade. My concern is with a particular painter, Richard Smith, who as much as anyone has manifested the process of painting as a single synoptic image. His assimilation of advanced painting has been omnivorous, but more remarkable is how he sustained a visually pragmatic way of painting through a succession of changes. It's the constants in his work that ultimately justify the hindsighted teleology that moves from the present position of his art to its beginnings, omitting nothing. The ease with which the development appears almost passively as internal logic may be attributed to his extraordinary visual intelligence and high consciousness. It should not, however, cause us to construe his process as directed to the present. The goal, if we may even speak of one, changed as each solution changed. He possesses useful obsessions which sustain an existential process for which modern criticism has the means to describe but not definitively understand.

Smith has been explicit about what motivations changed the more dominant characteristics of his style: "When an idea cannot be made visible within the terms I use, I recognize that conventions have been set up. The conventions then have to be broken." It's true this fixes the instigation of change, but not the emergence of ideas unpredicated on a mode of painting which denies the possibility. It doesn't explain how he recognizes limiting conventions from others that remain receiving, nor how such denying conventions are broken without impairing the more comprehensive processes that continue to assert rightness. Clearly Smith's development has operated on a number of inter-

dependent coefficients that express the degree his style is possessed by certain absolute values. So some module of self-criticism must be operating incessantly in his art to explain why no stylistic change in state has left behind anything of the previous state, and why no "broken conventions" actually broke the stylistic line. The presumed enmity between constancy and change doesn't seem to arise in his process; the constancy is marked only by change at moments of stress. It has been said that Smith expunged this, rejected that, or exchanged one mode of this or that for another. But if at one time Smith rejected images for pure abstraction, he soon recognized the abstractions as images. If he expunged brushwork in favor of uniform surfaces, he then understood that painting uniform surfaces entailed a special kind of brushwork. If he rejected illusionistic space in favor of the literal space of three-dimensional objects, he was forced to note that literal space too is illusionistic. Too much, in fact, of Smith's process has been subjected to art critic reductivism — the most impeding are concepts of rejection, reaction, and spent modes. The tenor of an existential style cannot be reduced to such mechanistic operations which deny the dialectical nexus that supports change within continuity and is as perpetually historical as tree rings.

Smith's evolution as a painter coursed through the 60s and 70s on both sides of the Atlantic. The fact that he is English hasn't bound him strictly to English art: Pollock, Francis, and Rothko were strong mid-50s impressions; between 1959 and 1966 he lived and worked intermittently in New York. A good deal in his New York-based art argues for identifying him with pop art, but the reservations he developed about it — that the source material was not sustaining — defines the essential aspect of his paintings since

the mid-60s. He was among the first attracted to advertising imagery. In London he was in touch with pop theorist Lawrence Alloway, and painter Richard Hamilton. But his first solo show was in 1961 at Bellamy's Green Gallery in Manhattan where Claes Oldenburg, Tom Wesselman, and other pop artists also showed first. So his links were with both London and New York artists as early as 1954.

In New York Smith also participated in the early 60s dialogue between painters Frank Stella and Larry Poons and sculptors Donald Judd and Robert Morris. Central to the art of this group were issues not unrelated to those of the pop artists. They too questioned the concept of art as representation or depiction, and were engaged in finding what might be the irreducible quality of a work of art: its physical rather than referential existence. Certain of the pop artists had found the irreducible quality of art in the media itself, or in the common object unelaborated by culture. Pop imagery was matter-of-fact, factual, and for a while the most direct exponent of non-artistic, hence non-illusionistic, art. The confluence at that time of the literal shape and concrete presence of the work of art (as in the work of Morris, Judd, Stella) and the literal imagery of pop art was propitious for a reexamination of all conventions of painting and sculpture. The many bifurcations in modernist art by the mid-60s defined the variables of this common reassessment.

It would be easy to say that Richard Smith never was a pop artist. That can be said now for about all the artists who bore the label. Once the local character of pop art — the historical artifactness — sifted out, what remained was quality and fertility of the experience for fresh growth. Smith didn't so much drop pop imagery as shift emphasis to other aspects of his

process that more positively and completely defined continuity in the conceptual change he was undergoing. Everything soon converged once again; his painting became more immersed in physical existence as the referential source material of pop art turned on itself so to speak and became physical substance. The substance, given over to thoughts about the physicality of the art object, was transposed to structure; in sequence, the structure of the canvas became shaped, then three-dimensional. Illusions became physical facts, like thoughts expressed with ever higher premium on status as idea. The paintings of 1964 and the new few years were given a positivist aspect and a self-sufficiency like sculpture's. It was by optical tactility rather than pictorial means that these objects deceived the eye if at all. Not only did they appear divorced from illusion, they paradoxically entered into it. Given corporeality, they came full circle and appeared as illusion in fact.

But the more literal kind of painting with its concreteness of shape and color relations harbored subversive qualities. Smith's new paintings occupied the same space he did and had to be dealt with quite differently from previous ones with spacial presence only when seen. Moreover, no matter how variously he constructed three-dimensionality, he felt a certain sense of loss — not at first, but later. In abrogating illusion he had accepted the more narrow, physical, and finally less imaginative experience of the physical art object — and also, he thought, the loss of color. He said in 1966 he was obliged to use fewer colors, and aim for colors that are matt in their final effect. The drawing was done then by the three-dimensional wooden form over which canvas was stretched, so the decision of figuration was made by the stretchers. Each facet, or delineated plane area, called for one color — a painting with two

forms to identify received two colors. His characteristic accumulative brushwork of the previous years — which he likened to the brushiness of a garden hedge changing fortuitously with light — was not assertive enough to define or modify the discreet shapes of the constructed canvases. It was out of character with shapes that had precise and totally identifying edges.

The complexity of the shaped canvases subverted the kind of color complexity Smith had going in earlier imagery. The intricacies of color then were illusionary. To apply this quality to physical shapes existing in real space would render them anomalous, like real fish in an unreal pond (as the old Chinese proverb on folly goes). The problem was revelatory, however. Smith articulated about 1964 that the complexity of his paintings involved vacillation between the real and the illusionary thing — one accepted while the other denied. But because everything happened within the permissive format of flat painting — all inside one idiom — the factual and the illusionistic could co-exist.

Or so he thought. To the extent that the illusionistic aspect was a comment on the kind of reality the "real" elements asserted, there occurred no serious detraction from pictorial integrity or concreteness. To renounce the illusion of space or light would entail a decisive statement that the real aspects of the imagery were real in fact, in which case the spatial imagery would no longer suggest space but rather exist within it. As long as the representational in his paintings did not do that, illusion continued to be admissible. It was finally overcome, however, by a desire to arrive at paintings of one thing, one image. Smith began to shape the canvas to fit the image. Becoming three-dimensional, the images entered into the spectator's space, became unconfusedly objects.

Illusion was squeezed out, along with its characteristic brushwork and color complexity. Smith was directly compelled to treat each surface shape as a facet of the single, de-differentiated structure. "When you paint across something that is three-dimensional," Smith said then, "the third dimensional reality is too strong for extra play with added illusion. You are severely restricted to painting what you've got."

Smith didn't carry out this restriction to the extent others did. Color had always been dominant in his work and the act of painting was not to be wholly subordinated to facticity of surface. What was thought to be a restriction on color became rather a more stringent demand on it. The earlier loose brushwork that operated with the aid of a controlled adventitiousness — transparent overlaps, the incandescence of the white canvas returning light to the eye, the interplay of stroke-line and surface — transposed into a more uniform color fabric which became the painting's fabric. The color was the color of itself, the radiance was from its surface; the source of appearance, in fact, was the painting. The requirement of non-referential self-sufficiency demanded more color sensibility than it disavowed. It compressed the spectral and textural range of the earlier painting — not in a narrowing or simplifying way like condensed narrative, but rather like poetry phrases charged with compressed thoughts that project full scale on the reader's mental screen.

Shaping is a way of drawing, in sculpture as in collage or shaped canvases. The shape of Smith's canvases since his 1963 Kasmin Gallery show, for all their tri-dimensional assertions that suggest relief sculpture, were still paintings. No law requires paintings to be physical in two dimensions and illusionistic in the third. The shape, Smith has said, is an aspect of color;

5

the canvas holds the color in a specific way; the distortion of the canvas membrane alters the way the color is seen. Variables in color, therefore, coincide with variables in surface.

The shaped canvas, however, imposes limitations. As Smith's lexicon of imagery called for new visual thoughts and their formal definitions, he expanded on the more visible or suggestive aspects of previous work and moved on. Earlier illusions of overlapping planes, as in *Piano* of 1963, became more explicit in *Clairol Wall* of 1967. During the next two years, in *First Half* of 1968, then *Fieldcrest* of 1969, the essential syntax of the "kite" paintings became established.

In a series of drawings made between 1969 and 72 a kind of recapitulation occurred: aspects of earlier paintings joined with those of later ones. A new synthesis of shape, texture, edge, and internal definition appeared — as if apocalyptic in one sense and antithetical in another. The complex shaped constructions, which had controlled surface for a few years, no longer seemed useful. Smith spoke then of their bulk and weight, and of practical problems of transporting and storing them. But more likely these were secondary reasons, handier for rejecting the three-dimensional shaped structures than the felt, but unarticulated, fact that they were no longer adequate to support a changing sensibility. It wasn't, I think, a practical but rather an aesthetic decision to "detach" the canvas from stretchers — as one detaches the skin from a tent frame — and support it by other means. The metaphor of a box skin, which was evoked in the earlier works, passed quickly through the metaphor of tent frame to that of the kite.

Smith had designed a tent for the Aspen Design conference in 1966. For an artist accustomed to erecting a frame and stretching canvas over it, the erection of a tent is the experience of an analogy, as is assembling a kite. But the analogy of kite fabrication is closer to a painter's sensibility; the box and the tent have greater affinity with sculpture, as both contain space and assert physicality.

Smith's first "kite" paintings were exhibited at the Kasmin Gallery in 1972. Wood struts supported the canvas tissues; later he exchanged them for aluminum rods. The "kite" constructions were analogous to kites: threads were stitched through the canvas, their ends dangled like tails; and the paintings were hung by string to find casually their own specific position. But the analogy stops there, as abruptly as did the billboard analogy for much of pop art. The value of Smith's works as painting cancels out references to anything outside them.

The overlapping "kites" introduce a new spatial positioning of pictorial elements. Though presaged in Smith's own development and related to work by other artists, their importance is in the continuity with the faceted shaped canvas and also in the way the individual units have edges and surfaces consonant with the method of fabrication and brushwork. The rectangular units of canvas are stretched and pulled by the tying; the surface not only receives paint but responds to it, as in *Star* 1974. A counterpoint of stretched rectangles and painted ones occurs in *Golden Russian* of 1976, where also appear references to the earlier three-dimensional pieces: the corners of the painted rectangles are cut off, or folded over; the effect is of spacial continuity not only in the overlaps but in the bending, as if the back side of each plane is asserted.

Many of these works exude a residual box-like echo, even hints of perspective that refer our eye to the box meta-phors of the early 60s, as to *Staggerlee* of 1963. But in the other paintings, like *New Skin b* and *Late Mister* of 1977, the stretched panel acts as both painting surface and ground for figurative-type elements that are tied on. In one sense these paintings bring Smith full circle, not in return or even summation, but rather in momentary consummation. An extraordinary restraint controls these images, a terseness even, which upstages what casual drama is enacted by the tugging of the framework and the loosely tangled tie strings. Hedginess comes forward once again as simile, but with greater poetry. The formalism is assertive, or is the casualness a way of hedging on it? At times it seems that one quality subverts the other: the geometry by the process, the dominant verticality by the slightness of the gravitational fall that expresses it. In *New Skin b* a small white square hangs corner-up beside its black painted shadow; combined they are askew, but the white element is rigorously centered. One's eye is captured by such ironic unities in which problems of balance and composition are rendered uncanny.

Livorno 1972
Acrylic on canvas with metal rods and
string, 78″ x 84″
Loaned by the Arts Council of Great
Britain

Pseudonym 1972
Acrylic on canvas with metal rods,
dowels, and string, 58″ x 58″
Loaned by Sydney and Frances Lewis,
Richmond, Virginia

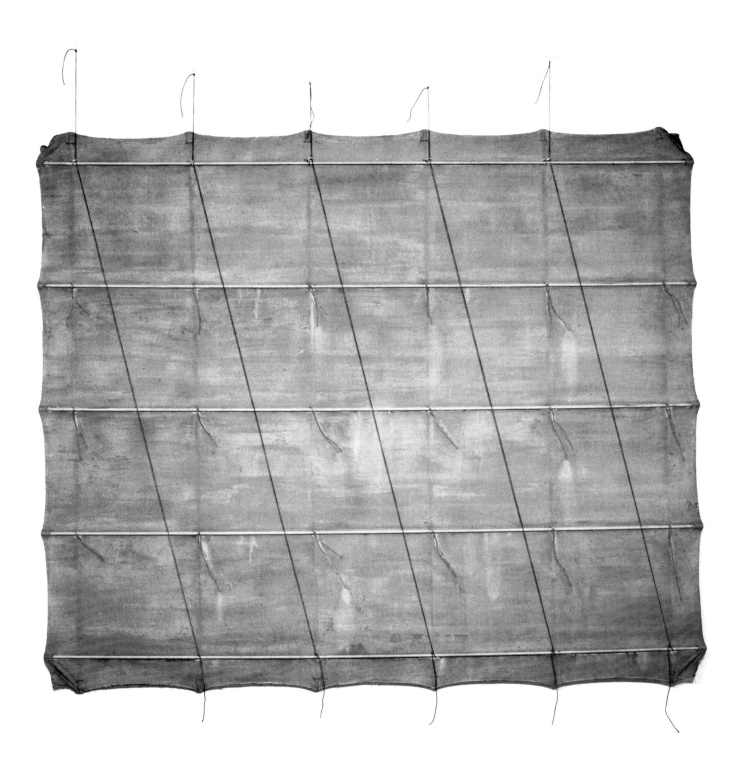

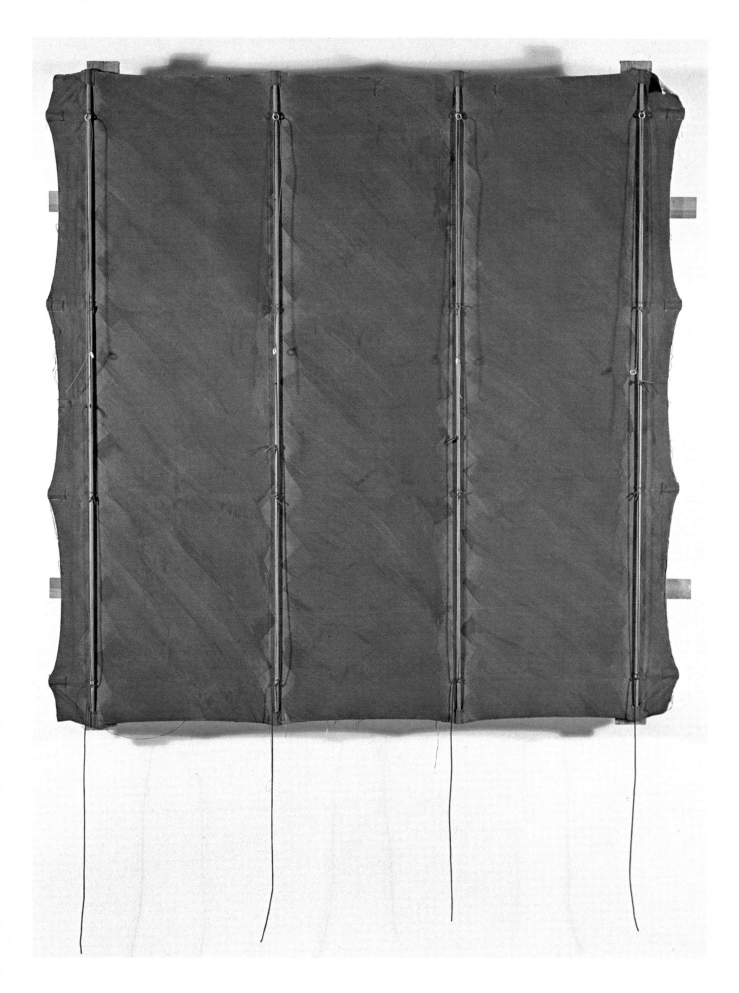

Sloop 1972
Acrylic on canvas with metal rods,
dowels, rope, and string, 78″ x 44″
Loaned by Sydney and Frances Lewis,
Richmond, Virginia

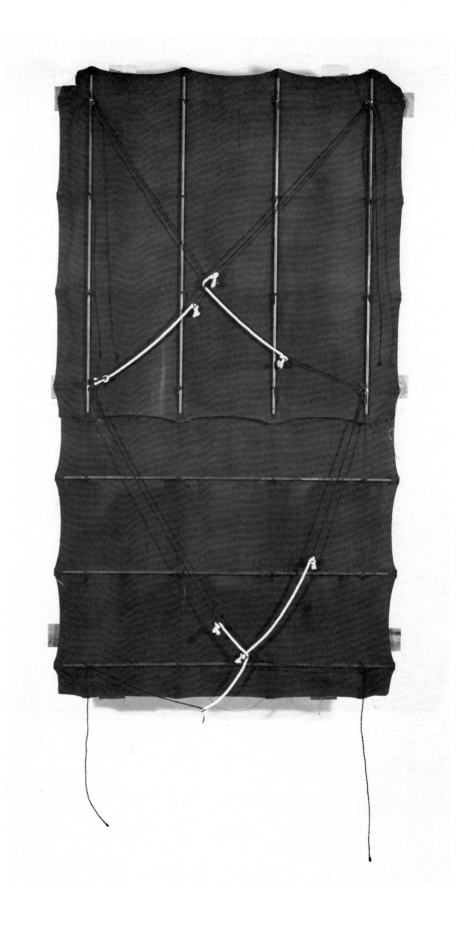

Banana 1973
Acrylic on canvas with metal rods,
rope, and string, 108″ x 18″
Loaned by the artist

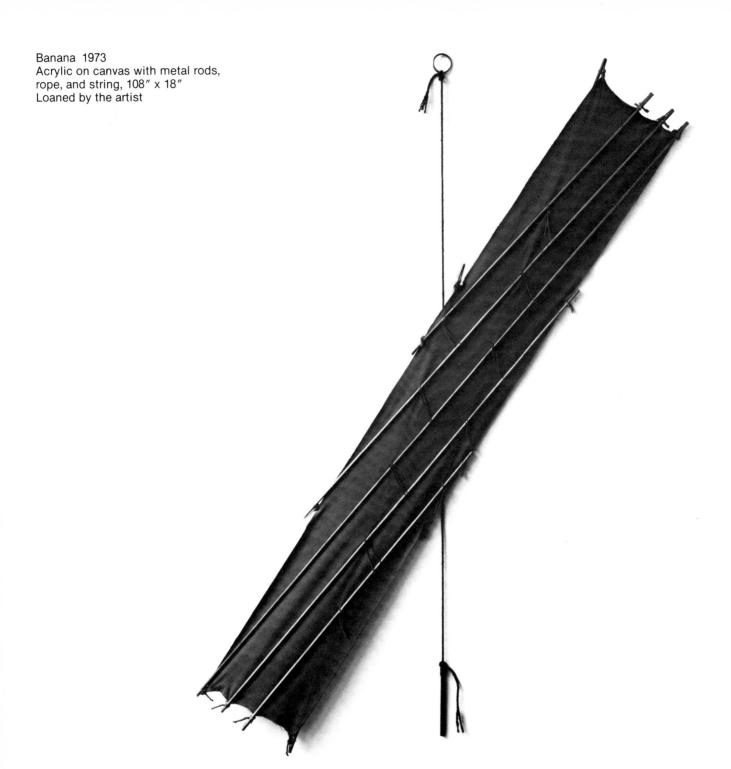

White Rope 1973
Synthetic polymer paint on canvas
with metal rods, rope, and string
126″ x 57½″
Loaned by the Museum of Modern Art,
New York

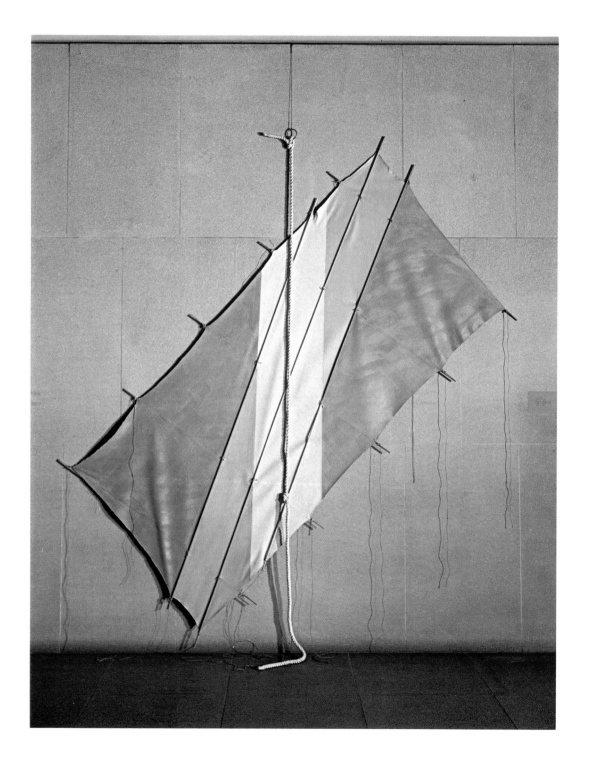

Star 1974
Acrylic on canvas with aluminum rods
and string, 3 parts, each 90″ x 90″
Loaned by the Gimpel Fils Gallery,
London

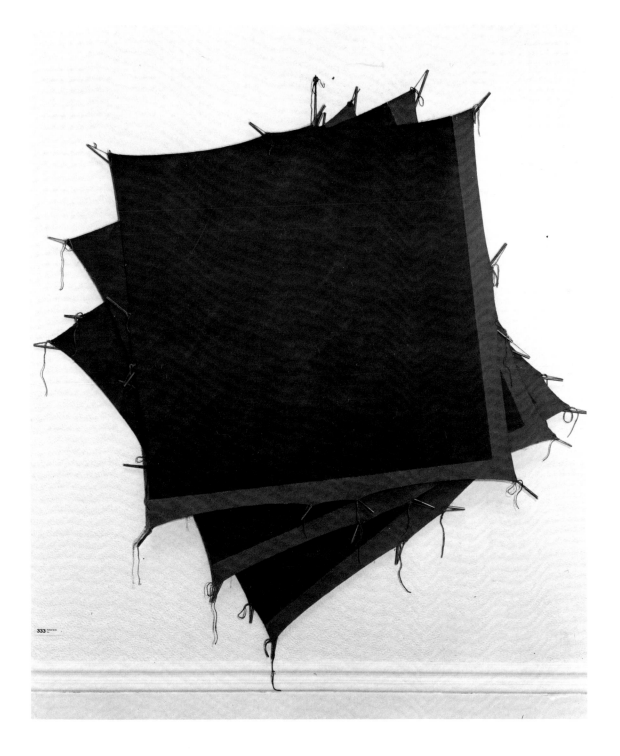

Grey Slices 1975
Acrylic on canvas with aluminum rods
and string, 4 parts, each 88½ ″ x 29½ ″
Loaned by the Young Hoffman Gallery,
Chicago

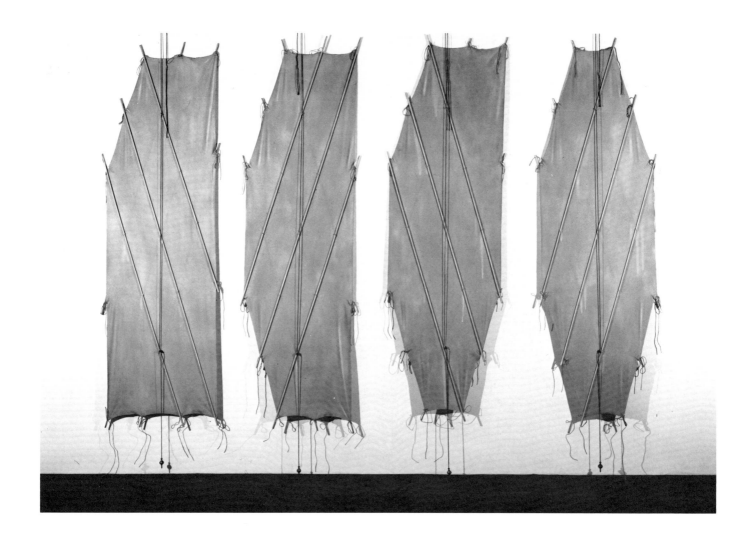

Cartes Blanches 1976
Acrylic on canvas with aluminum rods
and string, 84″ x 90″
Loaned by the artist/Hansen-Fuller
Gallery, San Francisco

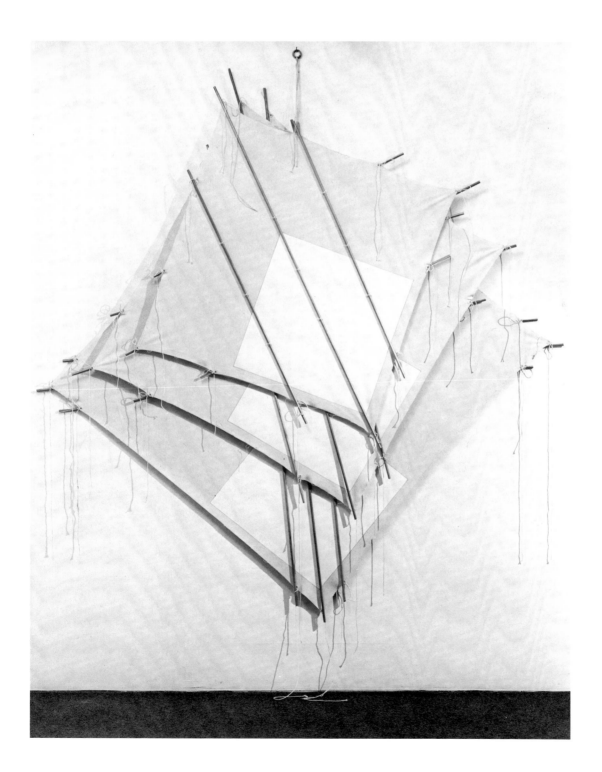

Diary 1975
Acrylic on canvas with metal rods and
strings, 7 parts, each 59″ x 59″
Loaned by the Krost/Chapin Collection,
Los Angeles

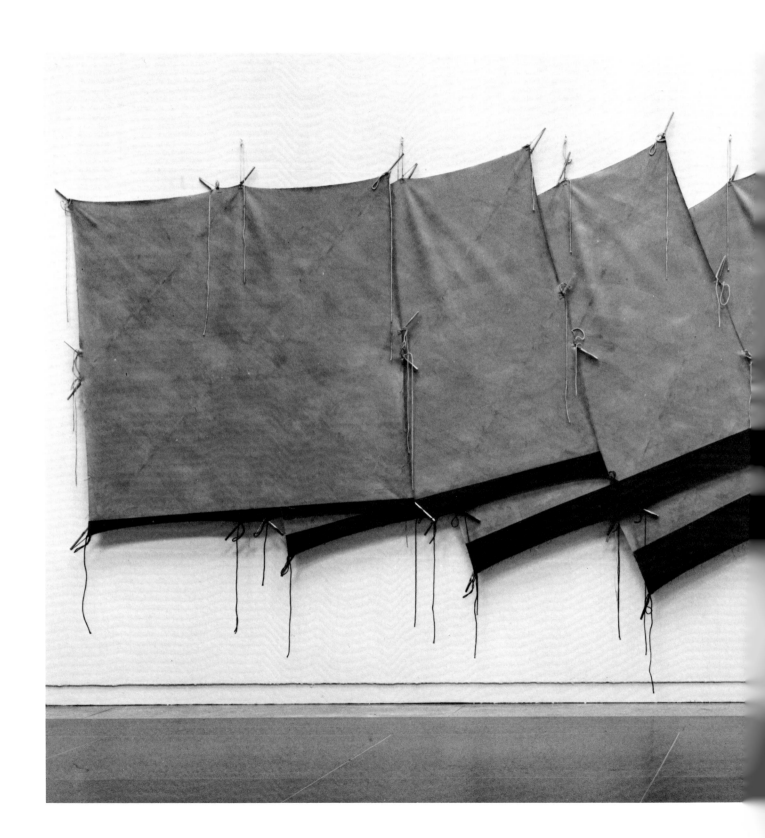

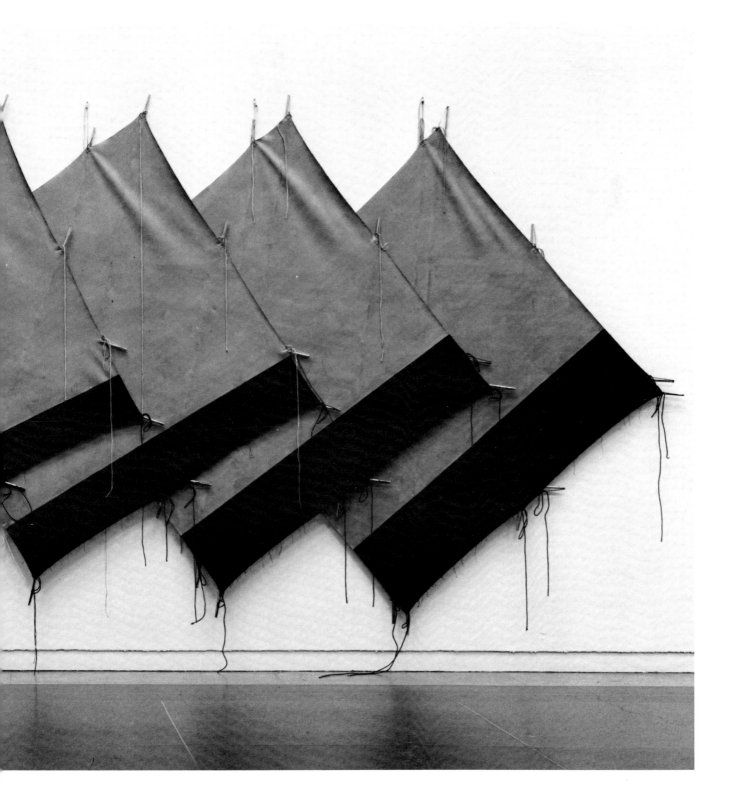

Five Finger Exercise 1976
Dyes on cotton with metal rods, string,
and rope, 5 parts, each 108″ x 36″
Loaned by the artist

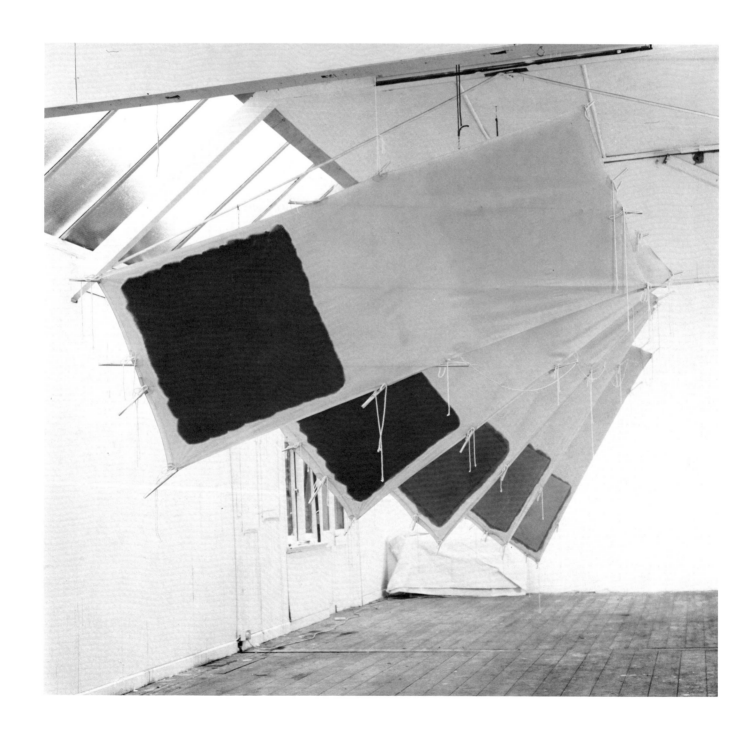

Late Mister 1977
Acrylic on canvas with metal rods,
dowels, and string, 55″ diameter
Loaned by the Young Hoffman Gallery,
Chicago

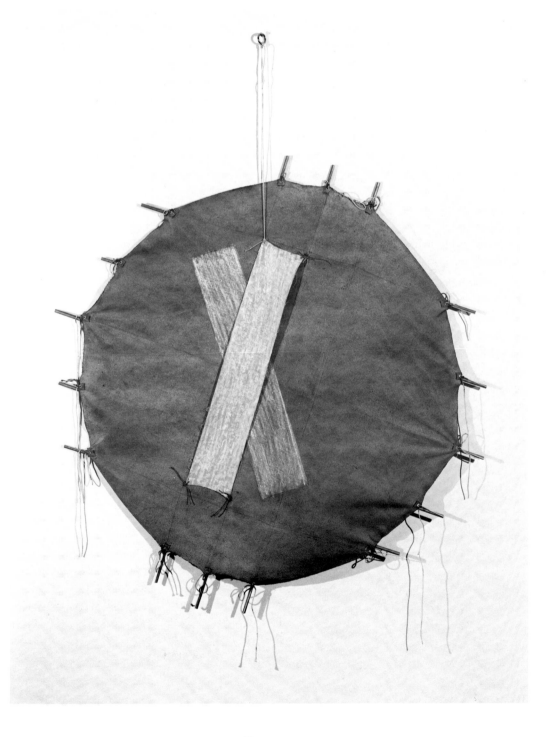

New Skin b 1977
Acrylic on canvas with metal rods,
dowels, and string, 47″ x 50″
Loaned by the Young Hoffman Gallery,
Chicago

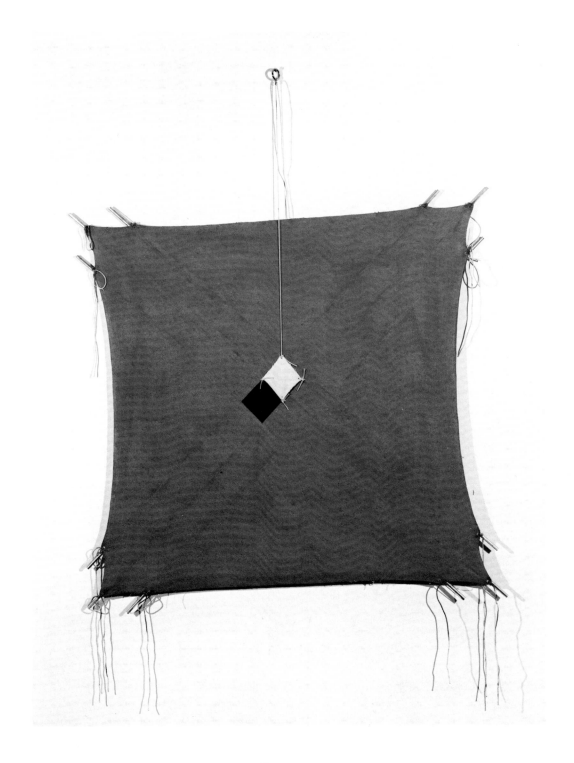

Golden Russian 1976
Acrylic on canvas with aluminum rods
and string, 84″ x 90″
Loaned by the artist/Hansen-Fuller
Gallery, San Francisco

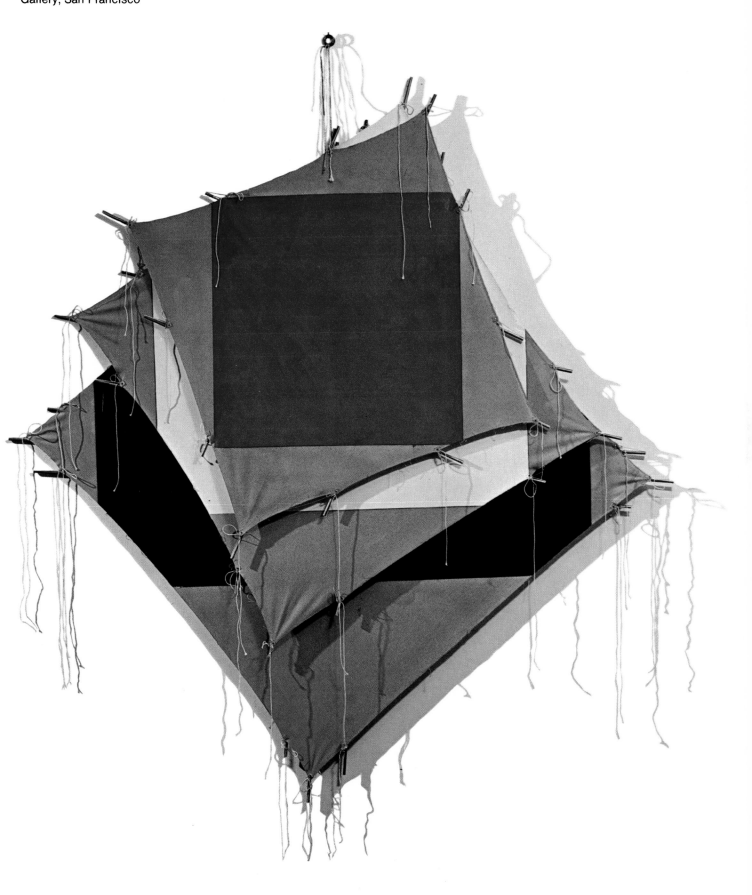

Catalogue of the Exhibition

Paintings

Livorno 1972
Acrylic on canvas with metal rods and string, 78″ x 84″
Loaned by the Arts Council of Great Britain

Pseudonym 1972
Acrylic on canvas with metal rods, dowels, and string, 58″ x 58″
Loaned by Sydney and Frances Lewis, Richmond, Virginia

Sloop 1972
Acrylic on canvas with metal rods, dowels, rope, and string, 78″ x 44″
Loaned by Sydney and Frances Lewis, Richmond, Virginia

Banana 1973
Acrylic on canvas with metal rods, rope, and string, 108″ x 18″
Loaned by the artist

White Rope 1973
Synthetic polymer paint on canvas with metal rods, rope, and string
126″ x 57½″
Loaned by the Museum of Modern Art, New York

Star 1974
Acrylic on canvas with aluminum rods and string, 3 parts, each 90″ x 90″
Loaned by the Gimpel Fils Gallery, London

Diary 1975
Acrylic on canvas with metal rods and strings, 7 parts, each 59″ x 59″
Loaned by the Krost/Chapin Collection, Los Angeles

Grey Slices 1975
Acrylic on canvas with aluminum rods and string, 4 parts, each 88½″ x 29½″
Loaned by the Young Hoffman Gallery, Chicago

Cartes Blanches 1976
Acrylic on canvas with aluminum rods and string, 84″ x 90″
Loaned by the artist/Hansen-Fuller Gallery, San Francisco

Golden Russian 1976
Acrylic on canvas with aluminum rods and string, 84″ x 90″
Loaned by the artist/Hansen-Fuller Gallery, San Francisco

Five Finger Exercise 1976
Dyes on cotton with metal rods, string, and rope, 5 parts, each 108″ x 36″
Loaned by the artist

Late Mister 1977
Acrylic on canvas with metal rods, dowels, and string, 55″ diameter
Loaned by the Young Hoffman Gallery, Chicago

New Skin b 1977
Acrylic on canvas with metal rods, dowels, and string, 47″ x 50″
Loaned by the Young Hoffman Gallery, Chicago

The Dominos I, II, III 1977
Acrylic and oil pastel on canvas with metal rods, string, and rope, 3 part series, each with four 82″ x 39″ sections
Loaned by The Prudential Insurance Company of America

Drawings

Double Appia 1970
Watercolor, 23½″ x 31¼″
Loaned by the artist

Large Pink Drawing 1970
Oil pastel and pencil, 39½″ x 57″
Loaned by Betsy Smith

Butterfly 1971
Oil pastel and crayon, 23″ x 57″
Loaned by Betsy Smith

Untitled 1972
Oil pastel, crayon and string
33″ x 43½″
Loaned by Edward Smith

Paper Clip Drawing 1973
Pencil and pastel, 27½″ x 27½″
Loaned by the artist

Untitled 1973
Acrylic, pencil and string, 36″ x 43½″
Loaned by Harry Smith

Drawing With String 1975
Watercolor, charcoal, and string
31″ x 23″
Loaned by the artist

Double Cross 1 and 2 1977
Acrylic and oil pastel
each 18½″ x 39½″
Loaned by Bernard Jacobson Ltd.

Graphics

Florentine Set 1973
Lithograph with string and transparent paper 18/75, 19¾″ x 27¾″ (set of two)
Loaned by Bernard Jacobson Ltd.

Lawson Set 1973
Lithograph with string 32/50
23½″ x 31¼″ (set of two)
Loaned by Bernard Jacobson Ltd.

Paper Clip Suite I 1974
Etching 11/25
5 parts, each 17¼″ x 17¼″
Loaned by Bernard Jacobson Ltd.

Parterre 1975
Serigraph 59/75, 20¼″ x 20¼″
Loaned by Bernard Jacobson Ltd.

Russian I & II 1975
Etching 21/50, 3 parts, each 20″ x 20″ (set of two)
Loaned by Bernard Jacobson Ltd.

Red Button 1976
Lithograph 13/50, 28¾″ x 31¼″
Loaned by Bernard Jacobson Ltd.

Garden City 1976
Lithograph 14/50, 28¾″ x 31¼″
Loaned by Bernard Jacobson Ltd.

Four Knots 1976
Lithograph 14/50, 28¾″ x 31¼″
Loaned by Bernard Jacobson Ltd.

Large Green 1976
Etching 19/35, 38½″ x 39″
Loaned by Irena Hochman

Large Red 1976
Etching 16/35, 38½″ x 39″
Loaned by Bernard Jacobson Ltd.

Grey 1976
Etching 44/50, 23¾″ x 24″
Loaned by Bernard Jacobson Ltd.

Orange 1977
Etching 56/80, 28″ x 27½″
Loaned by Bernard Jacobson Ltd.

Small Blue 1977
Etching 22/50, 26″ x 22¼″
Loaned by Bernard Jacobson Ltd.

Small Yellow 1977
Etching 41/50, 26″ x 22¼″
Loaned by Bernard Jacobson Ltd.

Burgundy 1977
Etching 21/50, 32″ x 29¼″
Loaned by Bernard Jacobson Ltd.

Large Blue 1977
Etching 53/60, 27½″ x 28¼″
Loaned by Bernard Jacobson Ltd.

Richard Smith was born in 1931 in
Letchworth, Hertfordshire, England.
Studied at Luton School of Art 1948-
50; St. Albans School of Art 1952-54;
the Royal College of Art 1954-57.
Served in the Royal Air Force, Hong
Kong 1950-52. Taught at Hammer-
smith College of Art, London 1957-58;
St. Martin's School of Art, London
1961-63; Aspen, Colorado 1965; the
University of Virginia, Charlottesville
1967; the University of California, Irvine
1968; the University of California,
Davis 1975. Lived and worked in New
York City 1963-65. Awarded the Royal
College of Art Scholarship for travel
in Italy 1957; the Harkness Fellowship
of the Commonwealth Fund for travel
in the United States 1959; the Mr. and
Mrs. Robert C. Scull Award, 33rd
Venice Biennale 1966; the IX Sao
Paulo Bienal Grand Prize, Brazil 1967;
the Commander of the British Empire
1971; the Bradford Print Biennale First
Prize 1976. Lives in East Tytherton,
Wiltshire, England.

The Dominos I, II, III 1977
Acrylic and oil pastel on canvas with
metal rods, string, and rope, 3 part
series, each with four 82″ x 39″
sections
Loaned by The Prudential Insurance
Company of America

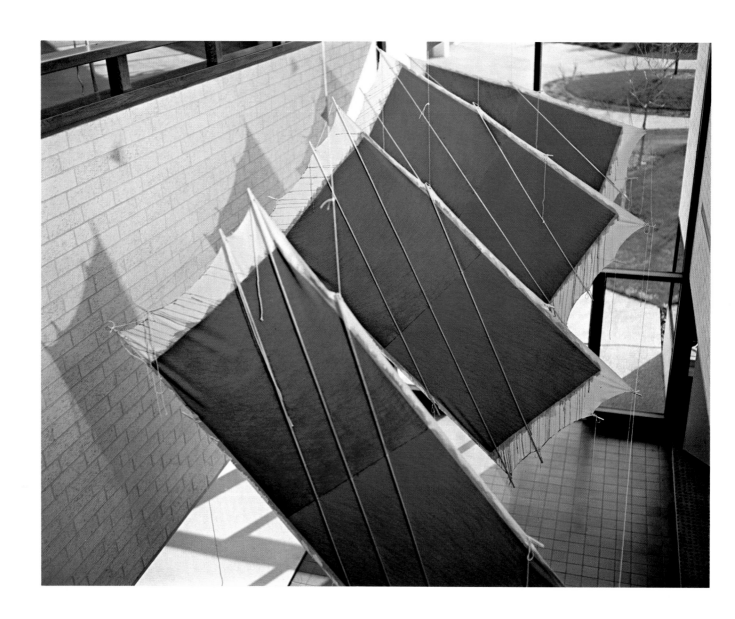

Butterfly 1971
Oil pastel and crayon, 23″ x 57″
Loaned by Betsy Smith

Large Pink Drawing 1970
Oil pastel and pencil, 39½″ x 57″
Loaned by Betsy Smith

Untitled 1972
Oil pastel, crayon and string
33″ x 43½″
Loaned by Edward Smith

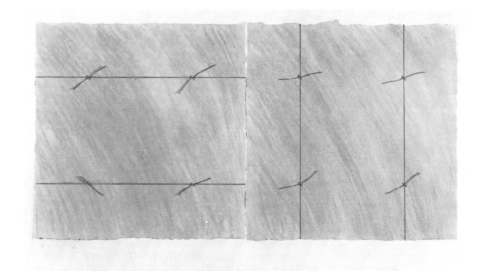

Untitled 1973
Acrylic, pencil and string, 36″ x 43½″
Loaned by Harry Smith

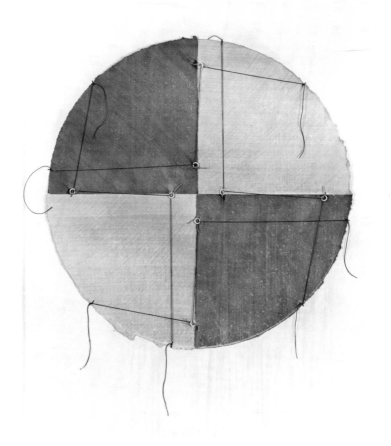

Drawing With String 1975
Watercolor, charcoal, and string
31″ x 23″
Loaned by the artist

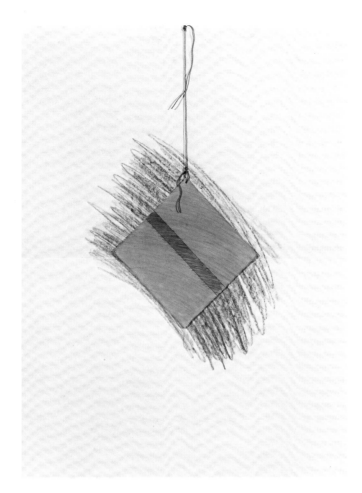

Double Cross 1 and 2 1977
Acrylic and oil pastel
each 18½″ x 39½″
Loaned by Bernard Jacobson Ltd.

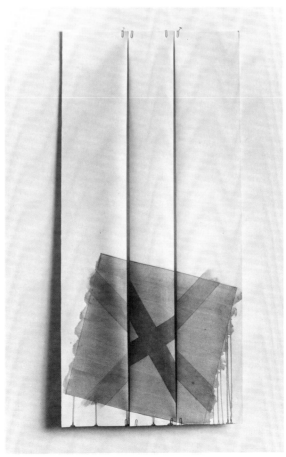

Four Knots 1976
Lithograph 14/50, 28¾″ x 31¼″
Loaned by Bernard Jacobson Ltd.

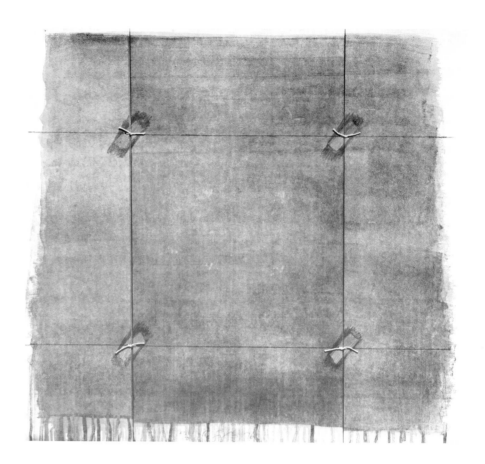

Florentine Set 1973
Lithograph with string and transparent
paper 18/75, 19¾″ x 27¾″ (set of two)
Loaned by Bernard Jacobson Ltd.

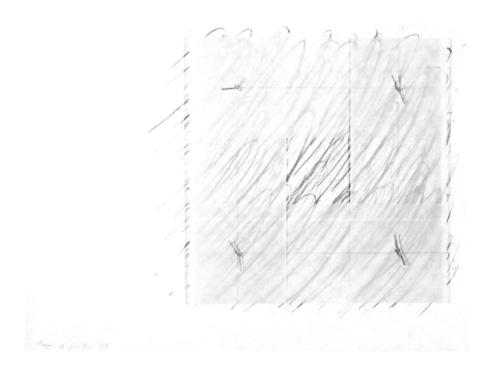

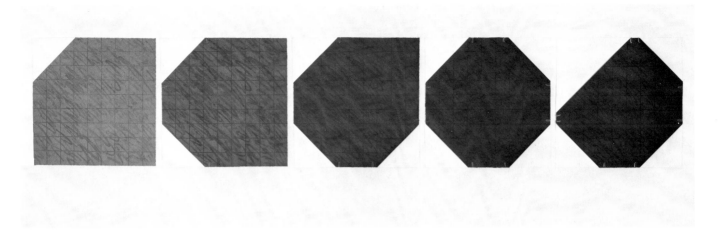

Paper Clip Suite I 1974
Etching 11/25
5 parts, each 17¼″ x 17¼″
Loaned by Bernard Jacobson Ltd.

Russian I & II 1975
Etching 21/50, 3 parts, each 20″ x 20″
(set of two)
Loaned by Bernard Jacobson Ltd.

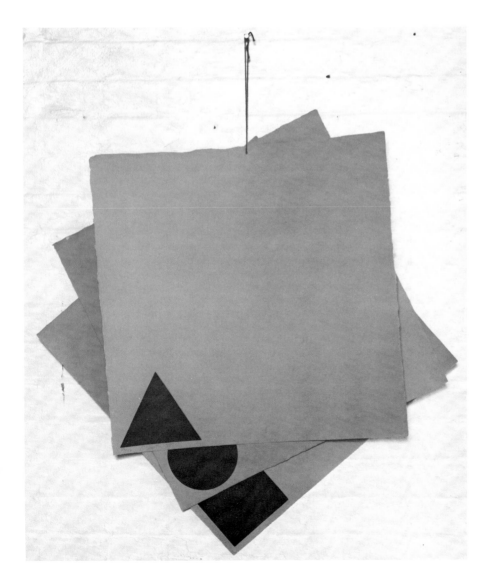

1972
Galleria dell'Ariete, Milan
Museum of Modern Art, Oxford
Bear Lane Gallery, Oxford
Kasmin Gallery, London

1973
Ruth S. Schaffner Gallery, Los Angeles
Garage Art, London
Waddington Gallery Graphics, London
Galerie Schottenring, Vienna
Chow Commission, Hayward Gallery,
London

1974
O.K. Harris, New York
Galerie Swart, Amsterdam
Neue Galerie, Museum of Linz, Austria
Galerie Schottenring, Vienna
DM Gallery, London
Bernard Jacobson Ltd., London

1975
Museo de Arte Contemporaneo de
Caracas, Venezuela
Kettles Yard Gallery, Cambridge
Gimpel Fils Gallery, London
Ashmoleon Museum, Oxford
Tate Gallery, London
The Arts Council of Great Britain,
Touring Exhibition
Museo de Arte Moderno,
Rio de Janeiro

1976
Galleria Vinciana, Milan
Gimpel Fils Gallery, London
Galleria la Polena, Genova
Galleria del Cavallino, Venice
Gallery Kasahara, Osaka,
Museo de Arte Moderno, Bogota

1977
Studio la Citta, Verona
Galeria Arte/Contacto, Caracas
D M Gallery, London
Galleria la Piramide, Florence
Studio Arco d'Alibert, Rome
Galerie Orny, Munich
Gimpel & Hanover Galerie, Zurich
Modulo, Porto, Portugal

1978
Artline, The Hague
Hayden Gallery, MIT, Cambridge

1972
"Contemporary Prints," Ulster Museum,
Belfast
Kasmin Gallery, London

1973
"La Peinture Anglaise Aujourd'hui,"
Musee d'Art Moderne de la Ville de
Paris
"Henry Moore to Gilbert and George,
Modern British Art from the Tate
Gallery," Palais des Beaux-Arts,
Brussels
1974
"British Painting '74," Hayward Gallery,
London
Bradford Print Biennale
Galerie Wellmann, Dusseldorf
"Small is Beautiful," Angela Flowers
Gallery, London
Musee d'Art et d'Histoire, Cabinet des
Estampes, Geneva

1975
C.A.S. Art Fair, Mall Galleries

1976
Bradford Print Biennale
"English Art Today 1960–1976," Palazzo
Reale, Milan
"For John Constable," Tate Gallery,
London
"For John Constable," Galerie Yves
Brun, Paris
"John Moores Exhibition," Liverpool
"Europa/America l'astratione
determinata," Galleria d'Arte Moderna,
Bologna

1977
"Five British Artists," Young Hoffman
Gallery, Chicago
"British Painting 1952-77," Royal
Academy, London
"British Painting of the 60s," Tate
Gallery, London

1978
"Graphic Studio U.S.F.," Brooklyn
Museum, New York

Arts Council of Great Britain
Blue Cross Blue Shield
The British Council
Calouste Gulbenkian Foundation
Granada Television Ltd., Manchester,
England
Hirshhorn Museum and Sculpture
Garden, Smithsonian Institution
Instituto Torcuato di Tella,
Buenos Aires
Massachusetts Institute of Technology
McCrory Corporation
Ministry of Public Buildings and
Works, London
Museo de Arte Contemporaneo de
Caracas
Museum of Modern Art, New York
Museum of Modern Art, Rome
Museum of Modern Art, Teheran
Peter Stuyvesant Foundation
Philadelphia Museum of Art
Power Gallery of Contemporary Art,
The University of Sydney
Prudential Insurance Company of
America
Tate Gallery
Ulster Museum
Victoria and Albert Museum
Walker Art Center

Articles

Boorsch, Suzanne
"New Editions (Diary)," Art News 75
(March 1976): 69-70

Burr, James
"Gap between Painting and Sculpture,"
Apollo new series 102
(August 1975): 140

Clay, Julien
"La Peinture Anglaise Aujourd'hui,"
XXe Siecle 41
(December 1973): 174

Crichton, Fenella
"London, Richard Smith at the Tate,"
Art International 19
(October 1975): 52-3

Crichton, Fenella
"London letter," Art International 20
(Summer 1976): 16

Denvir, Bernard
"London Commentary: Richard Smith
at Kasmin,"
Studio International 184
(September 1972): 85

Fuller, Peter
"A Pop-Out Reality," New Society 33
(September 11, 1975): 596-7

Greenwood, Michael
"British Painting 1974," Art Canada 32
(March 1975): 29-34

Hughes, Robert
"Stretched Skin," Time 106
(September 1, 1975): 42-3

Lucie-Smith, Edward
"Flying Kites," Sunday Times
(July 5, 1972)

Mainardi, Pat
"Richard Smith," Arts magazine 51
(January 1977): 44-5

Martin, Henry
"Milan letter,"
Art International 16
(Summer 1972): 108

Oliver, Georgina
"Richard Smith," Connoisseur 190
(September 1975): 74-5

Overy, Paul
"Richard Smith Flies a Kite," The Times
(August 19, 1975)

Packer, W.
"Radical and elegant," Art and Artists 8
(March 1974): 20-23

Reichardt, Jasia
"A Natural Painter," Architectural
Design 45
(October 1975): 642

Restany, Pierre
"Richard Smith is Back Home," Domus
552
(November 1975): 48-9

Rose, Barbara
"Richard Smith: An Interview with
Barbara Rose,"
Studio International 190
(September/October 1975): 165-7

Russell, John
"Exhibitions Abroad: London," Art
News 73
(January 1974): 76

Russell, John
"Richard Smith at the Tate,"
Art in America 64
(January 1976): 106

Solomon, Elke
"New Editions," Art News 74
(March 1975): 64-5

Taylor, Robert
"The most interesting exhibition in
London," Boston Sunday Globe
(September 7, 1975): A10

Tisdall, Caroline
"Seven Up," The Guardian
(August 13, 1975)

Trini, Tommaso
"La Scritura di Richard Smith," Gala
International 77
(May 1976)

Zucker, Barbara
"New York Reviews," Art News 74
(February 1975): 85

Cambridge, England, Kettle's Yard Gallery, and Oxford, Ashmolean Museum. "Richard Smith Drawings." 1975. Essay by Duncan Robinson.

Caracas, Fundacion Museo de Arte Contemporaneo de Caracas. "Paginas Amarillas." 1975. Text by Richard Smith.

Caracas, Galeria Arte/Contacto. "Richard Smith." 1977.

England, Tour Organized by The Arts Council of Great Britain. "Cut Folded and Tied." 1975–76. Foreword by Joanna Drew. Essay by Lynda Morris.

Genoa, Galleria La Polena. "Richard Smith." 1976.

London, Tate Gallery. "Seven Exhibitions 1961–75." 1975. Foreword by Norman Reid. Essay by Barbara Rose.

London, Gimpel Fils Gallery. "Richard Smith: New Works." 1976.

Milan, Galleria dell'Ariete. "Richard Smith." 1972.

Osaka, Gallery Kasahara. "Richard Smith." 1976.

Porto, Portugal, Modulo. "Richard Smith." 1977.

Rome, Studio Arco d'Alibert. "Richard Smith." 1977.

Teheran, Teheran University, Exhibition organized by the British Council. "Recent British Art." 1977. Introduction by David Thompson.

Venice, Galleria del Cavallino. "Richard Smith." 1976.

Verona, Studio La Citta. "Richard Smith." 1977.

Vienna and Innsbruck. "Zeitgenossische Britische Kunst." 1977.

Zurich, Gimpel & Hanover Galerie. "Richard Smith: Drachen-Bilder und Gouachen." 1977–78. Essay by David Thompson.

Faculty
Donlyn Lyndon, Chairman
Kenneth Brecher
Whitney Chadwick
Richard Eckaus
John Irvine
Heather Lechtman
Boris Magasanik
Jerome Rothenberg

Ex-Officio
Walter Rosenblith
Harry Portnoy
Peter Spackman
Marjory Supovitz

Students
Shelley Klapper
Jordan Kreidberg
Don Thornton

Staff
Marjory Supovitz
Projects Director
Stephen Ringle
Hayden Gallery Manager
Kathy Halbreich
Special Assistant to the Chairman
Elizabeth Horton
Registrar
Virginia Gunter
Compton Gallery Manager
Gary Garrels
Secretary
Jeff Schiff
Gallery Manager's Assistant

Photograph credits
Greg Heins page 27, 28, eeva-inkeri page 27, 28, Dennis McWaters page 8, 9, Schopplein Studio page 14, 20, Desmond Tripp Studios page 17, 24, 25, 26, John Webb page 26, Donald Young page 13, 18, 19.